The First Year After The Fifty

The First Year After The Fifty

Selected Works 2020

Jayne Lyn Blair

Copyright © 2020 by Jayne Lyn Blair.

ISBN:	Softcover	978-1-7960-8947-9
	eBook	978-1-7960-8946-2

All rights reserved. No part of this book may be reproduced or transmitted in any form or by any means, electronic or mechanical, including photocopying, recording, or by any information storage and retrieval system, without permission in writing from the copyright owner.

Any people depicted in stock imagery provided by Getty Images are models, and such images are being used for illustrative purposes only.
Certain stock imagery © Getty Images.

Print information available on the last page.

Rev. date: 02/24/2020

To order additional copies of this book, contact:
Xlibris
1-888-795-4274
www.Xlibris.com
Orders@Xlibris.com
798082

CONTENTS

FILM .. 1

POETRY .. 25

BOOK .. 49

STORY .. 55

COLLEGE GIRLS, LUCKY LADIES
AND RICH WOMEN ... 79

ART .. 91

Dedicated to My Natural Parents

James and Reva

and

Grandparents

Clifford and Charlotte

George and Olive

PREFACE

<u>The First Year after the Fifty</u> is collection of the writing of Jayne Lyn Blair, which includes five different genres'. Twenty five years in the making, yes a quarter of a century, it spans from summer 1994 to winter 2019. Many of the pieces have not been printed before for an audience to read or distributed. This book can be enjoyed by the young and the old.

For the most part, being a member of the American Workforce for 50 years was a phenomenal experience. I enjoyed the work-place immensely. Numerous opportunities came my way and I gratefully struggled to keep them.

The past year 2019 and <u>"THE FIRST"</u>, I celebrated with the completion of this book. Also I am very grateful to XLIBRIS for inviting me to publish again.

FILM

Criticism and Reviews

Hollywood Extra, Extra. Published by Xlibris 2011 has 15 pieces Miss Blair has written approximately 100 reviews.

KING ARTHUR

Legend of The Sword

The movie King Arthur, Legend of the sword, still after 3 months has left me spellbound. No wonder Author has become such an important word, term and noun in contemporary life! To my surprise AUTHUR'S legend occurred around 600 A.D. by some reasonable dating stragedies, which is about 600 years after Julius Ceasar entered Briton as the first Roman to discover a robust crowd, skilled as chariot riders and horsemen, who valued their freedom!! This is a movie you will have to see for yourself to absorb and appreciate.

GUY RITCHIE, was challenged from all corners, his child ROCOCO, Madonna, the press and the Great film makers world over who came, all in less than the first 30 minutes. What a sight to have seen! The ELEPHANTS who were parading along were unbelievable and early, made it clear Great movies are being produced, cast paid for and truly have an audience ready to appreciate them!!!

ARTHUR was very articulate in the movie and did achieve remarkable feats, as he appeared to indeed be gifted and or talented, unusual to say the least and thus his name has survived as the AUTHOR the authority!!!

Outrageous. An incredible emergence: an author with a story.

Well Done!! A masterpiece for true deliverance to the movie goer of a story and era so long ago.

In a Class By Itself.

Highly recommended.

ROCKETMAN

(Nominated for an Oscar Award and was a Winner
February 9, 2020 in a Music Category)
Elton John
Starring: Taron E.

Taron E. gave a performance of Elton John, the pop rock musician, who rose to towering heights, in the last 40 years as a leading entertainer that was a REVELATION.... indeed a revelation not to be missed.

The 2 hour movie, which hit the box offices at the beginning of the summer May 31, 2019, billed as Rocketman had alot of fanfare. It left no surprises and no disappointments.

Carefully constructed and in fact produced by Elton John himself, the flick included lavish costumes and famous stages from the very early years of his life. The gig at The Troubadour in Los Angeles, an early gig thrilled the audience leading the fans to Ceasars Palace on the Las Vegas Strip. I visited Las Vegas in 2003-2006 and saw his PIANO Man Poster in the Hallway of the popular hotel resort and vacation spot in Nevada!!! I had discovered Elton John years ago in the early 1970s as he was a radio rock star favorite with the hit...YOURSONG....You may remember the lyrics too:..." if I were a sculptor but then again no..or a man who makes potions for the traveling show...this song is for you..."

Soul bearing in the well written story line of his life and struggles with fame and success, which leaves him in a class by himself, the audience was overwhelmed with his dedication to his keyboard playing and incredible sensitivity to carrying a melodie line further and beyond to stir the souls of every ticket holder. IMPRESSIVE. Indeed a superstar, untouchable except to the increasing pressure to experiment with the intoxification of the sold out stadium and performing stages as a PIANO PLAYER: the popular song singer. Bernie, skill as a poet carried a good portion of the load, but it was Elton Johns love of stars, lights, color fashion, excitement and the thrill of it all together as the soloist that painted the NAME on the HEADLINES of Newspapers everywhere and sold the million dollar record albums. No kidding!!! See it TONIGHT!! He will indeed still be standing for years to come with the hit after hit collection!!

A STAR IS BORN

Starring Lady GAGA and Bradley Cooper

In the 2 hour and 15 minute movie box office hit....

A STAR IS BORN starring Lady Gaga, (Stephanie Joann Germanato) Lady GAGA hit the jackpot, finally indeed. At the last 15 minutes she, ALI, snatched her Andy Warhol's 15 minutes of fame that will carry her into the next 4 decades of her life as a performing diva, a singer, singing a tune. Her red highlighted hair was neatly teased and curled on the top of her head and her long evening gown fit perfectly and she has what it takes to be on the center stage singing A VOICE, worth millions! No ands, ifs or butts!! She has arrived.

Near the first of the simply filmed reality flick, Bradley Cooper held the spotlight for nearly 2 hours as we were delighted to learn he can sing and plays the guitar. We already knew he could dance well when he starred in THE AMERICAN HUSTLE and with Amy Adams danced the night away in a disco club. Together GAGA and Cooper, a dynamic couple who gave their all deserve a nod!! Now they have received them: Golden Globes, Critics Choice Awards and The Screen Actors Guild Awards all noticed. This weekend The Grammy Awards will be aired on television and The OSCARS from The Academy of Arts and SCIENCES will host their presentation on Sunday February 24th, for more applause and red-carpet excitement. It appears Gaga will

have a future on any and every stage in the world, maybe the LIDO in Paris where I had dinner once or The Colesium in London, where I saw Nureyev dance in 1983, besides the Kennedy Center and Lincoln Center in Washington and New York City respectively. I saw Lady Gaga sing when she was on tour in March 2011 at THE DELTA CENTER in Salt Lake City. Her AGENTS will have to make sure, certain she has a hair dresser to help her comb her hair besides the finest dress makers in the world at her doorstep!!

WINSTON SPENSER LEONARD

CHURCHILL
Darkest Hours
Starring Gary Oldman

 This outstanding movie from the motion picture industry SPEAKS for itself!!! It does not need a critic's review or commentary. Anyone and everyone that is a movie buff will want to see this great movie experience that brings to life the personality and depth of world famous Sir Winston Churchill. Outside of the opinion that this movie was not long enough, this flick production has no flaws what so ever. It maybe one of the 10 best productions by a cast and screenwriters in the last 20 years.
 Carefully, the family life of Prime Minister Churchill, sweet and charming was revealed; along with the passionate devotion of the British citizens seen in the short episode of the UNDERGROUND train riders, quoting no-less the lines from the well known poem of THOMAS Babington M.,..." the ashes of our fathers and the temples of our Gods...", with Sir Winston Churchill; and the HORROR of WAR!!! Moreover it should be noted or remembered Winston Churchill won The Noble Prize in 1953 for his 6 Volumne <u>HISTORY of the War</u>!

AMERICAN MADE

Starring Tom Cruise

Tom Cruises performance in American Made...MADE THE GRADE!!! Cruise thrills his audience and challenges it. The story of Barry Sills demanded complete and total concentration to absorb and understand his passion and he had plenty. Early on we learned he worked as a pilot for American Airlines. The TWA pilot flew Americans everywhere: Denver, Portland, Los Angeles for the weekend or a get away!!!

His wife, well cast, and love of his life fueled his determination and the story line even further. What a plot and a pilot! People can only wait for so long and there is no turning back! Time marches on and no time to waste!

Beautiful CRUISE at his best and best grade, with flying skills.

We too felt the passion of Barry Sillls and his dreams. Moreover we felt his pain and sorrow as he left the scene indeed Check it out. For Barry Sills was being powerfully investigated by the United States government airflight border patrol for smuggling drugs into the States illegally, near the gulf of Mexico and Central America in his private plane.

You decide..........

KING KONG

KONG and the UNKNOWS

King Kong an old figure in the movie industry returned to the silver screen in all his glory this past year. The movie was worth the wait since it had been at Tinseltown for 3 weeks or more but I saw it later for the $2.00 senior price at Cinepoint on 12th Street. Fantastic!! – such a story with the M I A (Missing in Action) veteran soldier who was alive on the island where K O N G thrived, -- with the most incredible locals, the painted face people, the natives in the South Pacific. Near by are the 14,000 Indonesians islands, you may recall.

K O N G the Great Chimp was KING indeed. A must see movie. Good work Hollywood!

Love it.

REVENANT:
A MOVIE OF ENDURANCE!

 Moreover it is a cinema (large scope cinematography) with panoramic views of North America like you may never have seen before: THE RUGGED Snow packed Peaks of a fiercely and almost godless land, the steep mountains of Alberta Canada.

 The struggle included primarily male characters: trappers, frontiersmen, but also for a breathless moment and thus redemmed by a "R E V E N A N T A W E" that echoed Christian religious overtones and touched the human soul and even the fingertips of God!!

 THE AUDIENCE FOR THIS EXTRAORDINARY ARTISTIC MASTERPIECE would perhaps fall into 3 camps:

1. Individuals with early America heritage, like the Pawnee Indians
2. The fanatic participants of the environmentalist movement, mountain hikers
3. And finally the loyal fans of Leonardo Di Caprio.

CINDERELLA FILM CRITIC

OGDEN
August 2015

Disney and Company presented the fairy tale of Cinderella for the digital age and the jet setters of all economic levels. These are the ones ready and eager to stroll the gardens, window shop the Haute Couture Boutiques and business and most of all dance until the strike of midnight at the Grand Balls and Parties of Europe and elsewhere. WELL DONE WALT and Company!

Plus, C A T E B. was an entertaining and humorous step mother with 2 colourful daughters:

F U NNNNNNY! Gorgeous hairdo!

Cinderella will be showing on Monday August 10th in Ogden at dusk downtown....

LADY GAGA

Starring in MACHETE KILLS

Lady GaGa, the darling of the pop rock stages and radio stations left herself wide open as she debuted her motion picture acting skills in a role in MACHETE KILLS, to the hour glass figure and refinement of AMBER HEARD, Miss San Antonio.

The cast went all out to inform and up-date the viewers of the continued blood, gore and guts found along the Mexican border with GAGAs ganster role along with gun after gun after gun, to try to derail the rampage and bloodshed in the neighbor, bars and brothels, back roads of the drug cartel Lords, speaking in ENGLISH!

The problem is obviously gross! The gore and gut was too gross as well. Her furture as a serious actress is uncertain. Her future in other space and stages is certain. Her make-up, hair and costumes we sooooooo refined.

AMEN.

DARK SHADOWS

Starring Johnny Depp

Remember DARK SHADOWS was a remarkable, miniature replica of a GOTHIC ROMANCE NOVEL, complete with a haunted house, supernatural events and a racey romance starring the stellar movie actor and matinee idol Johnny Depp. In this case, further it was terrifically underscored by the 1974 mega pop radio hit:

YOU ARE VERYTHING

Recorded by Barry White. A movie certain to have been enjoyed by several audiences including Depps fans and the 19th century literature scholars and buffs.

Post Script:

I bought the used cd of Barry Whites hit at GREY WHALE and continue to enjoy it.

127 HOURS

Starring: James Franco
Written by Aron Ralston
Film Criticism by Jayne Lyn Blair, March 2011

It should come as no surprise to the audiences of one of televisions most popular occasions, THE OSCAR night that James Franco a new face and new name to the actor roster, hosted the two hour extravaganza with another big star, Anne Hathaway, after seeing 127 hours at the movies. The 1 1/2 hour motion picture released last year to the sharp critics and social crowds of Redford's Sundance Film Festival in Park City's yearly pilgrimage, probably won't leave each, viewer inspired and cheerful but they will leave their cushion seat and popcorn snack with a heightened awareness of the emotion of "WILL" the will to survive.

Filmed primarily, in the Granite Furniture Warehouse in Salt Lake County from a book written by the lone survivor who lived to write and tell his horrifying story of his catastrophic fall from his bike in the canyons desert near Blue Mountain and Big John where his right arm was mercilessly trapped by a giant boulder.

After four days of bewildering thirst and solitude, he stabbed his arm with a blunt crude pocket, knife until he cut it off like slicing a footlong Sub sandwich in half to free himself. Then moreover he carried his lifeless and frail body to a rescue helicopter and hiking threesome.

Aron Ralston, who <u>became a name</u> gives the viewer a clear choice in his daunting episode of life or death.

In addition the filming on location in the desert provided the audience an awesome and powerful view of wilderness and panoramic landscape complete with rain stormes, cloud movement and gigantic rock formations in nature.

Besides being a movie that could educate countless of search and rescue team members, aspiring dirt bike riders, mountain climbers and Saturday afternoon boy scout hikers that must learn this one legendary rule, do not ride alone, the cinema fans of the movie can contribute to the financial security of this lone survivor with a second LEASE ON LIFE, A SECOND LIFE TO LIVE WITHOUT A SECOND TO LOSE.

POETRY

Decree of Merit from The Cambridge
Biographical Center England 1995

Contest Entry - Lenore Marshall Award
Academy of American Poets

<u>Perfume</u> 2003

THE INTERNATIONAL BIOGRAPHICAL CENTRE
CAMBRIDGE · ENGLAND

DECREE of MERIT

In recognition of meritorious achievements
now made known to all people in all countries of the world,
the International Biographical Centre of Cambridge, England
hereby awards this exclusive

DECREE OF MERIT
to

Miss Jayne Blair

who has made an outstanding contribution to

Literature

The International Biographical Centre,
known and respected throughout the field of
biographical reference, has caused the publication
of
**THE WORLD WHO'S WHO OF WOMEN
THIRTEENTH EDITION**
to be made, this including the above-named
Decree recipient

Given under the hand and seal of the
International Biographical Centre

Authorized Officer. Authorized Officer.
Cambridge · England Dated January 1995

jayne blair

all rights reserved

WHEN ALL THE WORLD SPEAKS ENGLISH

VOLUME 2

SONNET ONE HUNDRED AND ONE

In Moscow's Red Square where soldiers march round
Bold, brilliant flowers, petals and bloom that mark
Beginnings and ends centuries old
The people wait to see your dancers, bow.

They fly from London and storm your city
Leave Paris after the Bastille party
Send teens on the trains from Rome like rebel
Soldiers that guard and read my poetry.

Like myself a noble pilgrim I too
Flew thousands of miles in the night, love
To Moscow with the Bolshoi stage to find
Years after I took Roses to your grave.

The truth and beauty I found there.
The stage and empty royal boxes of the State.

Jayne L. Blair
Use glyph AGA Arabesque D6 to all corners

SEDONA

Oak Canyon near Sedona will never
match the beauty of the Rocky Mountains
in October but don't tell the Mayor
of Flagstaff, I told you and your friends so
because you know how they gossip over
liquor in this town of happy hour.

But any canyon carved so deep and wide
with red rocks that bought the Grand Canyon fame
deserves a name of its own and some time
for people like me and for him and her
with lush spots that were meant for housing
of such peace.
There are lofts alone, large with vantage points
privacy and views nestled on the rocks,
on dusty back roads with sign for selling
acre by acre of vacation landscape
meant for POETS, HONEYMOONERS AND GOD.

So you see, Sedona, Sedona west
and south of the Las Vegas Strip and limelight
has no light on at night in the streets
just fires burning and candle light.
Then God's sunshine in the day time, by George
for strippers and the crowd that we call home
Monday morning at the band on fourth street
just down from City Hall.
Yack, Yacky, Yack
lap-top dancers, margaritas at happy hour
and your bottom dollar spent on black jack.

COUNT YOUR MONEY

Count your money everyday, find out what you are worth,
Count your nickels and your dimes and all that's in your purse
But don't forget the man out there who doesn't have a job,
And don't forget the girl next door who put you where you are,
With garment bags, limousines and all her haute coutour.

Count your money day and night like Ebenezer Scrooge,
Count those vouchers and those bills and your credit cards
But don't forget the man out there whose black, without a job
And don't forget the girl next door that doesn't have a car.

And LOUIS and his orchards and Charlesmagne's court,
Mark Anthony's naval fleet docked at Cleo's shore,
And London Bridge and Turner's oils and Hollywood's decor.
Cause kings and queens and other folks have suffered with more
And left their pets and furs and jewels beneath the Royal Door.
Like Alexander in Moscow and LOUIS's Paris Party
And Quasa and Oday who burned with Bagdad's poor.

So count your money everyday, dollars, dimes and credit cards
Count those coins and cash accounts and thank your lucky stars
For friends, and fans and endless fame that put you where you are.
But don't forget the lonely and the veterans of the WAR.

And LOUIS and his orchard and Charlemagne's court
London's Bridge and Turner's oils and Hollywood decor
Cause kings and queens and folks have suffered with much more
And left their pets and pools and jewels at the Royal door,

Like Alexander in Moscow and Louis's Paris Party
and Quasa and Oday who died with Bagdad's POOR.

<div style="text-align: right;">
Jayne L. V. Blair
Poem in Your Pocket Day 2019 is on April 18
</div>

Jayne Blair tried twice, all things considered to write a pop song. First with Americord in Hollywood with her Haiku poem and secondly with this poem <u>Count Your Money</u>. This song included the music she composed, a vocal she sang with her Yamaha Electronic keyboard she played and a CD recording of the pop song at Digital Insight Recording Studio in Las Vegas Nevada circa 2005.

WHITE

For all he was there, no,
for all she was there, there
that night, was all she was.
Or ever could be. There or anywhere,
in that dress, that red, mauve, black dress,
like a locomotive, the old kind,
like the coal that burned inside.
Or rather, white like lightbulbs, those whales, clouds
or swans' feathers,
those whales, clouds, or swans' feathers
any of a hundred thousand sights of white:
soft white rabbits
or the brittle white egg shell,
so tell them so.
More like the lines in the skies of planes
or the first snowfall of winter,
as a white blanket covering all
or the whiteness round your eye
or even opal white or ice white
that kind of white.
White like the rolls and rolls of paper for the butcher
or a banner for the politician
white like the museums, monuments and columns
circling, straddling, radiating
from the center of WASHINGTON'S dome.
White like that of the scores and scores
baskets and buckets of salt water pearls
yes, like the white pearls

sold near the amusement parks for tourists and cash
like that! There in that dress that night.
That was who she was.
Unfettered, uncluttered
full, sleek and tight,
short and backless and bare.
White like that, the snow, the eggs, the swans, the cotton
the swans, the pearls, the whales
like that, **white**
the whiteness of those familiar shapes of white.
Can you see that white dress
and her in it, there that night?
And if not
see her in all those other ways
knowing it was like her that night
in that dress there.
In the pearls, all of them
white like that pearl, the snow, the cloud, eggs
each and every piece of chalk,
before it is run across the blackboard
or all the lace that trails anywhere
tables, windows, veils, gowns, handkerchiefs
all there and more, like white Italian marble
or white limestone. **WHITE!**
All this in white.
White in their complete stance of wholeness,
independence
perfectly round like a circle.
White like a circle, fixed as it were,
unchanging, without surrender, ever there
like the rush and flush of wind blown waves, high and
mighty.

See the whiteness of a circle!
Complete, smooth finished from beginning to end
with no beginning or end
white like a circle there in that dress.

 Direct from New York City, Miss Jayne Blair has recently taken up residence in Ogden, Utah. Her poems have been published in *The American Poetry Anthology; In A Different Light;* and in *The Best Poems Of The 1990's.*

BATMAN - THE DARK KNIGHT

White knights and fairy tales, recall
Were all in the story books,
And Santa Clause and the Wizard of Oz
Made every dream come true
Superman flew in the sky and Zorro rode his horse
Saved men and women and kept the kids alive.
Don Quioxite and Sancho Panchez rallied underdog and common folk
Though born three centuries ago
Soldier Boy and Barbie have always lead parades
And Jesus Christ and Elvis King gave grace and life and hope.
So dream your dreams and get your girl
ONLY REACH for the stars
For Batman and his entourage rule the holy night
Saves True Love broken hearts and LIVES IN HOLLYWOOD.

THE SUMMER I FELL FOR YOU

The summer I fell for you, you were everywhere
You were with me even in my car there
When I ran the stop sign and hit my head
So hard on the steering wheel that it bled.

You were with me on the STRIP with the crowds
Where I read my poems and they clapped and wow-ed
As flappers and Englishmen from British pubs
Recite verses of slavery and of love.

You were there when I wore the red beaded dress
Sown with genuine pebbles, then caressed
With your hands while sunbathing at sunset
Like you see in the movies with the jetset.

Year after year where our eyes meet fast,
Our hands clasp and you let go of the past.

OH LITTLE LOVE
WHY DO YOU FLY TO ME?

Oh little love why do you fly to me?
Fly in at night with gold dollar stars,
Dance in the city, that's new and timeless
And fly out again with the rich and hungry.

Oh little love why do you fly to me?
I have nothing to give you, no money
My boy, I have nothing to share at all
And my clothes are not new nor expensive.

Oh little love, why do you fly to me?
I am not your love, and your dressed up doll,
With braids and curls and sapphire eyes,
Nor is my smile like porcelain tea cups.

Oh little love fly to me?
I am not the style hound like you hunger for?

#11

Has anyone told you, you're my MOON RIVER
... 'you heart breaker wherever your going'...
Don't leave me behind, you are mine, you're mine
Stocking the shelves and reading the news.

Has anyone ever told you, you're my Moon River
A dream maker a heart breaker ...'
That's moving faster than the STRIP can take,
And you didn't ever leave town for the weekend.

Has anyone told you, you're my Moon River
... With two drifters off to see the world.
The world that I created and you paid for
That Brad, Jolie and the babies want to govern.

Has anyone told you you're like a river
Fast and reckless and that will embrace the sea.

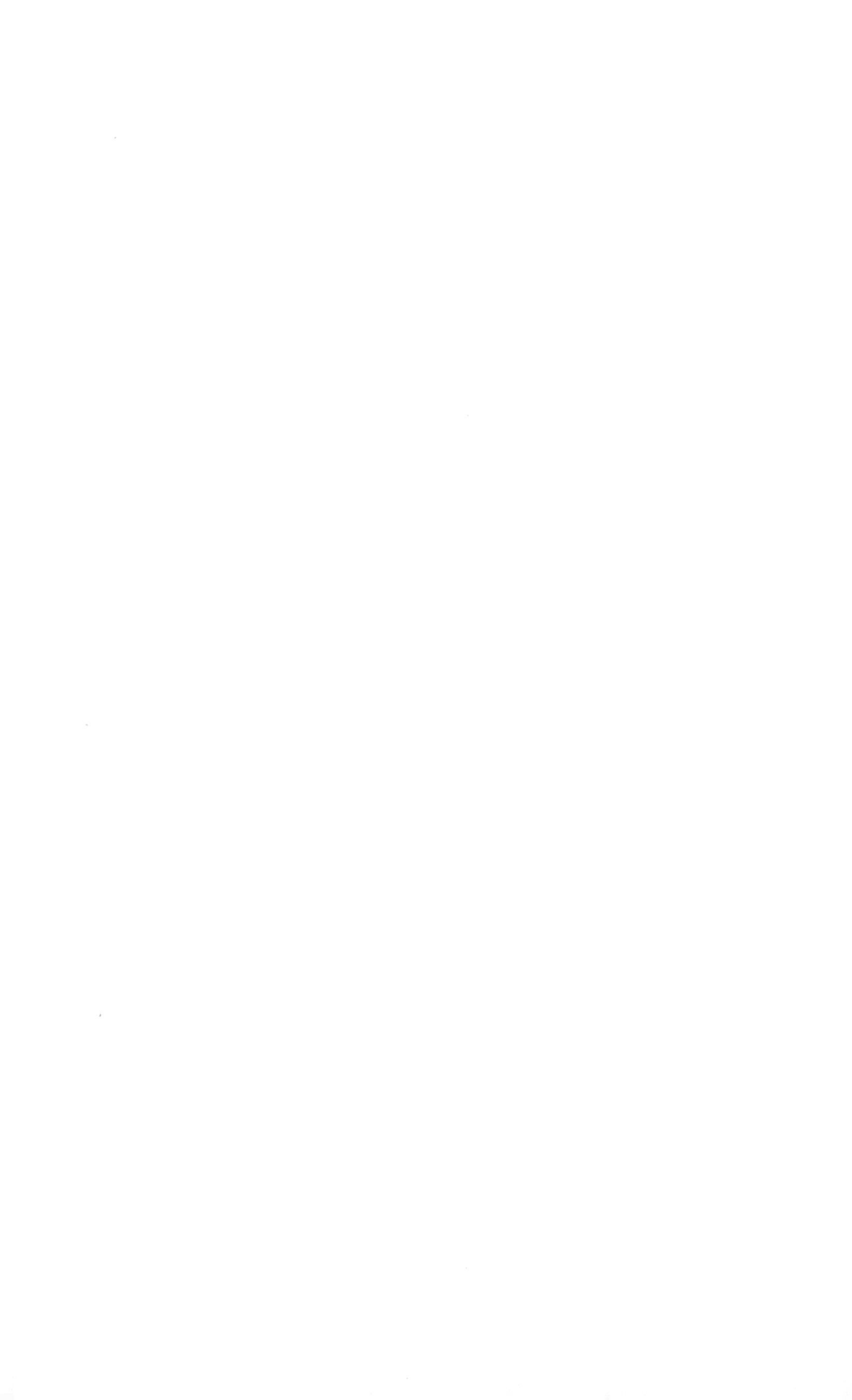

QUIET IN THE NIGHT

Fall ends quietly,
with the colors gone faded
all the leaves have dropped
the evergreens burnt
with the brisk cold days.

There's a hush with the snowfall
the streets are slippery
and the sidewalks are wet
the mountains seemed covered with cotton
from the first snowfall.

Through this wet ice, slush
young boys and girls tread to school
yell to their best friends,
"did you bring the ball?"

These voices echo
are lost again until recess!
like the chimes at noon
at all the old schools.
By late December
the desks in rows are pushed aside
the lockers empty
and the final grades in,
such an end to Falls brightness!

A closing dated and stamped
like a curtain closed
like a dead end street!

The good boys and girls
faithful and strong students,
the campus football hero
and this years homecoming queen
the bookworms' with glasses
the part-time students that work nights
the post-graduate crowd
all mingling around
some sigh and cry in the corners,
others laugh and mock the poor
plan to retire at 21
like a redeemed blue-ship stamp book that's empty!
to these and others
it was not that thy questioned not,
nor knew the answers
simple in their form,
it was worse yet still they had lost a voice,
and thus lost the fight, quickly pigeon-holed
or pampered like a dog, with anything
and everybody around them.
They had lost the fight, that came quiet in the night.

BOOK

Addendum to <u>JUSTICE</u>

Published by XLIBRIS 2004

Nonfiction

Miss Jayne Blair

*requests the pleasure of your company
at a Book Signing and Reading
of "Justice"
Tuesday, the nineteenth of January
Nineteen hundred and ninety-nine
seven p.m.
Ogden Egyptian Center
The Gallery - South Entrance
2415 Washington Boulevard
Ogden, Utah 84401*

ADDENDUM

to JUSTICE

Fall 2017 as I prepared for my last year in the American workforce and cleaned and cleared my files dating back to papers from my elementary school days (report cards). I decided to take action about the legal incident in Honolulu Hawaii in September 1980. I clearly wrote to the courts in Honolulu and THE STATE that led the suit and legal case and asked them politely to RELEASE Billy J.V. who as far as I know was still serving a life sentence without parole. I had decided in my older age that 31 years was long enough to pay his debt to society and he had at that point. He came to Hawaii and the United States to work, but did not follow the rules and it cost him dearly. Let him be RELEASED and move on with his life if possible. I have tried to do so myself.

I never heard from the courts of the State of Hawaii. I have remained single all my life. I am glad I have taken this action. Very important and with time enough..!!!!!!

STORY

THE SUNFLOWER RESORT

College Girls, Lucky Ladies and Rich Women
The Cartier Wrist
The Coffee Shop
The Cover Girl Look

Miss Jayne Blair read her story
THE SUNFLOWERS RESORT,
To the children at The Bookshelf in Ogden, her hometown.

~

Childrens Reading Contest Entry
J. Newberrry Medal for Childrens Literature 2000

THE SUNFLOWER RESORT

Summer is so beautiful. The weather is just right, with sunshine to walk in the park, or to ride your bike. Maybe mom and dad or grandpa and grandma can take you for a drive in the family car to see the DINOSAURS bones in Utah.

As you drive back through the canyons notice all the pretty flowers, sunflowers with bright yellow petals along the roadside: tall ones and short ones, with a long stem.

I cut a large pretty sunflower a wild one, for my home, from the side of the two-lane road at the mouth of the canyon.

I had arrived home safely, enjoyed my day at the DINOSAUR excavation site.

Soon as I came inside my home, I carefully filled a flower vase, for the wild sunflower. The sunflower sat proudly in my living room.

It wasn't very long until out on the petals, bright yellow and soft like velvet or silk, several creatures, small insects came to rest on the petals edge, from the brown center of the flower. A red ladybug, an ant, a spider, a fly, a beetle and a potato bug. WOW! Six tiny insects were relaxing on the petals of the sunflower, a SUNFLOWER RESORT!

Were the tiny insects on vacation? Perhaps so! At THE SUNFLOWER RESORT! I carefully watched the fly, rest his wings at his side, and clear his eyes with his antenna. Then the pretty red ladybug, would walk and promenade up and down her very own petal. The potato bug no less would crawl slowly along and then curl into a ball! And the black ant just sat on the tip of the yellow petal as though he was ready to jump off!! Oh how the insect enjoyed THE SUNFLOWER RESORT.

I did my best to make their stay happy and pleasant. I carefully changed their water for the SUNFLOWER so that it was clean and fresh. Then I opened a window near by to let the mornings' breeze into my study. Oh how happy were all the tiny and small insects at THE SUNFLOWER RESORT. Ladybug with her red shell, a black ant, a spider and a fly, the bug and a beetle, all pausing for the simple joys of summer.

The next day on Saturday, for I brought the sunflower home on Friday, I played my radio and records. WOW all the insects the, ladybug, the ant, the spider, the fly, beetle and potato bug crawled quickly to the center of the flower into fuzzy brown pad at the top of the stem! The sounds of the music, MOZARTS 40th Symphony had startled them. BEETHOVEN'S 'Moonlight Sonata' did the same. Nor did the insects like hearing the radio 'rock & roll' singer with his band.

So I quickly turned the music down very low and out came the insects, resting and sunbathing on the petals at my SUNFLOWER RESORT! The ladybug, and black ant. The fly spread his tiny wings and flew to another petal. The beetle and the potato bug walked slowly down the petal together! No longer were they scared by the sounds of the music!

On Sunday morning I went to admire THE SUNFLOWER RESORT. Early that day the insects rested comfortably on the YELLOW velvet petals, the sunflower had started to WILT! Oh dear! THE SUNFLOWER RESORT season was nearing an end. How sad I was to know that the small tiny insects, the red ladybug, the fly, the black ant, the spider with 8 legs and the beetle and the potato bug would not be able to stay another day on the petals of the yellow sunflower!

I had kept the sounds of music low, my voice quiet too, the air from the window mild and changed the water in my vase carefully each day. How I have enjoyed the insects each one at THE SUNFLOWER RESORT, as they walked, strolled, promenaded and rested on the yellow velvet petals, to the edge of the petal and back to brown fuzzy pad in the center of the flower above the stem!

Early Sunday, I took the wilted Sunflower with the marvelous insects, each one tiny and small as they are and placed the long wilted flower and stem in a dirt pile outside behind my garage. There the tiny insects, the red ladybug, the black ant, the fly with his delicate wings and the spider with 8 legs, the fuzzy beetle and potato bug that could curl into a ball, could easily and happily crawl from the wilted yellow sunflower petals onto the earths dirt and find another flower or weed, vegetable or tree leaf to rest on and peacefully enjoy another day or season at natures' resort! Maybe even die of old age and decay in the dirt, with the flowers, weeds, vegetables, fruit, trees, and brush.

THE END

COLLEGE GIRLS, LUCKY LADIES AND RICH WOMEN

PREFACE

Take off your seatbelts and toss out the books for fools and read Jayne Blair's Collection!!!

Join the mind of the woman, a non-traditional female without a husband, a kid or a pet, who rocked the poetry readings for a decade, WON THE WEST FOR A SECOND TIME THROUGH HARD WORK AND "JUSTICE," and set the standard in living and caring that left generation X a trail they could trust and travel. After Allen Ginburg died, it was this writer that from coast to coast led the way for the world after the millennium.

Her writings will inspire and give you courage to make the world a better place to live in.

THE CARTIER WRIST

A Short Story

He was quite obese to say the least, I mean his belly was ripe, full like an amber orange pumpkin or a ten pound watermelon and he was bald too. He wasn't even that tall, say for example like Mr. Irons who starred in that one adaption of Proust's "<u>Swann's Way</u>", and certainly not your television star type or any of those plastic card ladies of Dynasty or Dallas or the other soap operas. His nose was a bit large and he even carried a turkey like double chin, but besides having hands that were well placed and well cared for it was the look of his face and the way he dealt the cards. He was a dealer at the Tropicana Hotel in Atlantic City, about two and a half hours away from Manhattan for Black Jack or Twenty One. And he was the absolute best one.

He didn't smile; he didn't actually act that nice; he didn't even hang around that long; even though he did make an overt cough out of no where once, and it was not accidental. He looked tough in the tuxedo shirt and the yellow bow tie did him justice not like some of the other dealer loosely trying to pass off their job as a way to make a buck, but the bow tie did him justice because of his job, his work, shuffling cutting, splitting, laying and counting the cards and chips moved into circle of a highly refined skill, closely resembling artistic like the execution of

elegant dining in a four star Michelin restaurant by a European, rather Parisian trained waiter. And I stood there and watched.

I watched his hands as they laid the cards, the clubs, the hearts, kings and an occasional ace; I watched his eyes as he counted the points and distributed the chips; I watched him move from table to table to relieve the other dealers and finally saw him rush off in a quite impertinent way that revealed his impersonality yet appropriateness for the kind of night spot that it was.

He was the best I had seen having not been around the casinos all the much, although I did visit Reno and Las Vegas, somehow I missed the casinos in Baden-Baden and the ones near Monte Carlo in Nice and Moscow, well were certainly too steep for my company. I stayed there about 2 hours or at least one and a half hours because I remember checking my watch at 1:05 and then of course at 2:15 quickly trying to decide if I should leave or stay. I left. But I watched the cards flow, saw the aces laid, the dealer win for the house and an occasionally lucky player strike while my emotions swelled standing there like black velvet stallion, to be watched, ridden or worshiped. And my pulse started to take a heavier stride and my breathing picked up so that I just took big deep breaths and finally I had been there long enough that the galloping waves of my blood had eased off and all the activity of the entire casino, all the slots clicking away; all the glittering lights, like tiny Christmas trees bulbs; all the craps and baccarat and roulette table; all the gamblers, all the cocktail waitresses like playboy tricks had vanished away into a sheer vacant backdrop and there was only the black jack dealer table, his stack of cards that he dealt with a fast wrist and me. I whispered to myself all day about him.

He wanted me to stand there forever.

THE COFFEE SHOP

A Short Story

There was this girl at work, near Forty-second Street and Lexington and she wasn't the wealthy Jr. League type with a famous family or a lot of money in her hands, but very attractive and she was always by herself it seemed. She worked a lot. She had that steady job, the nine to five kind, but that gave that steady income that was so necessary. I don't know what she did, or where she worked, but the woman next to me in the coffee shop at the top of the stairs in the Graybar Building next to Grand Central Station said, "Oh she's a secretary in one of the offices, upstairs."

We saw her there a lot, at least once a week, just in for coffee or soup. She always had a cigarette and left a respectable tip.

One day apparently she had a conversation with the woman I talked with and she told her how she enjoyed living in Manhattan. She said she had moved here several months ago and was taking ballet lessons. She looked like she studied ballet, because her legs were so thin, like all dancers, firm and muscular, and she enjoyed wearing short skirts. And then the woman said she had told her about this one man in her past. It was a while ago, and she had gotten over him, but he still seemed to linger within her so to speak. "How was that?" the lady asked. "Well, every day he crossed her mind," she said, "everyday she wondered about

him, if he had moved; if he had a lover; if he had a steady girl if he had ever gotten married; or if he was already married and had lied to her." She said she felt the pangs of having ever met him, wished she hadn't in fact, because somehow the memory of him always got in the way: his success; his money; his power. And even more than that and by the same token, her lack of success, her lack of money and her total lack of any real power. She said all these things mattered to her, a lot.

And yet everything she did, every way in which she did achieve, she did in a quiet subtle way for him. All of her work was for him, any part of it that was especially beautiful, brilliant or original, all of which she highly admired she did with him in mind.

But she had decided and discovered that the damage had gone too far and there was no turning back, the clock or time and she would never trust him again. And in doing so she was shocked at his level of insensitivity and irresponsibility. What were women for? They can go make it with a gay guy just as easily with no fear of unwanted pregnancy, and what about aids?

She wondered if a broken heart were actually physically, that is biologically possible. She thought it probably was.

We don't see her at the coffee shop any more.

THE COVER GIRL LOOK

A Short Story

She walked into the door number 10 that the receptionist had instructed her to go into and meet the agency's executive assistant. Several years ago she had taken a 6-week modeling course, actually to learn more about fashion and makeup than really ever having the ambition to be a model. I mean real models were tall – five foot seven inches or more in bare feet – and they were all in New York, not here in the basement of the Hilton Hotel in downtown Las Vegas, Wednesday nights at 6:00.

And she did learn about makeup and a little about fashion, and certainly saw the press and the fashion magazine's photographer that got that perfect, magical picture for advertising because she had had the fashion photographer take one of herself, in fact more than one: one in an evening gown with jewelry around her neck, one in a black-velvet, strapless dress that you were only supposed to wear after 5:00 p.m., and a old, but gorgeous fur coat. The pictures captured for all time her natural beauty. That was several years ago.

Wilhelmina's competitive model agency had scheduled for her for a "go see," but something came up, probably her employment. She was a dependable employee and there five days a week. She had to be. She was single, independent, brilliant, and had style! She remembered

reading that the property owners on Madison Ave. said . . . "STYLE IS EVERYTHING!" The model booker at Wilhelmina's liked the fur coat shot and said she included it in her Fall catalogue, even though it was a few seasons old and taken in the West near the Grand Canyon, Arches and Bryce National Parks. This was now in New York near 57th St. in Manhattan and London and Paris.

She looked good today and felt even better. She was thin and her skin was so pretty, and besides having a face that once made up looked like a cover-girl face, she had a mind blazon like bronze, and that was the real reason for every invitation to the ballet or the theatre or dinner.

"Miss Blair, you are only five feet tall, not tall at all. . ." she said. "Had your manicure and pedicure?" "Yes," I said, "just yesterday. Those Chinese girls look all the same that give them for $15." "Well, let's see you in a swimsuit?" "How much do they pay?" "Well, you see, Miss Blair," she said, "it depends. But sometimes $500 a day or more and the bookings might last for five or six days." It depends on the photographer, but that was top pay no doubt. She left, and the assistant said she would be in touch and asked if she had an answering machine.

She went back to her room on 57th St. that she rented by the week, money changed hands quickly in New York, and wondered how she could fashion a life around one-day and one-week bookings. **LET'S FACE IT, A GIRL IN A DRESS HAD A PRICE TAG ON IT...** But what would happen if she didn't get along with the photographer or he wasn't a gentlemen and wanted to take advantage of her? What if one thing led to another and something happened that was unprofessional by anyone's standards?

She left it in her mind in limbo because somehow she couldn't reconcile surrendering in that way. Surely the famous models of the past like Twiggy in the mini skirt, Cheryl Tiegs' makeup line, Iman, that married David Bowie, Jerry Hall that married Mick, to Marisol that opened as a visual artist years after her modeling career, and now Kate Moss who would always stay in London and had questioned in their own jobs what was the fee and price tag for a girl in a dress. All of this crossed her mind. She knew she was strong enough to take the chance and help her generation discover the beauty of the "strapless

dress" again. Besides, maybe she could work just part time with the bookings... It seemed she preferred to take the risk even with several cold and sleepless nights as she waited for the phone to ring and decided she wasn't going to be something like an escort.

It was going to be about the work, those pictures year after year on the front of VOGUE, of the pictures of the careless lightness and ephemeral look of some girl or lady in a dress by the house of Dior, Ungaro, and now Tom Ford or Versace. NO! It was for the work, a booking for the shots of these dresses, the picture of a girl dressed with style!

She was determined to reinvent the dress for her generation, short and maybe very shapely. Besides, what if the booking turned out to be bad and the guy was gay or out of focus with his work? She decided she wouldn't let that get in the way and take it as it came. Maybe she could break into the market somehow.

In the morning before going to the studio she went to buy an answering device to catch those calls...

ART

Painting

<u>The Displacement Art Technique</u>
Copyright 1998

<u>The Painted Lady Christmas Tree Show</u>
Artist Statement

Music

5 Centuries of Classical Harp Compositions

Commentary-Criticism by Miss Jayne Lyn Blair

Miss Blair performed extensively as a classical harpist since 1962 (in a class recital at Kingsbury Hall at the University of Utah) and as recent as summer 2019 at the Farmers Market scene at noon just off Historic 25th Street in Ogden Utah. Her original composition

<u>I Gave You So Much and Carried You So Far</u>
Hit the Market after 2012.

DISPLACEMENT ART TECHNIQUE

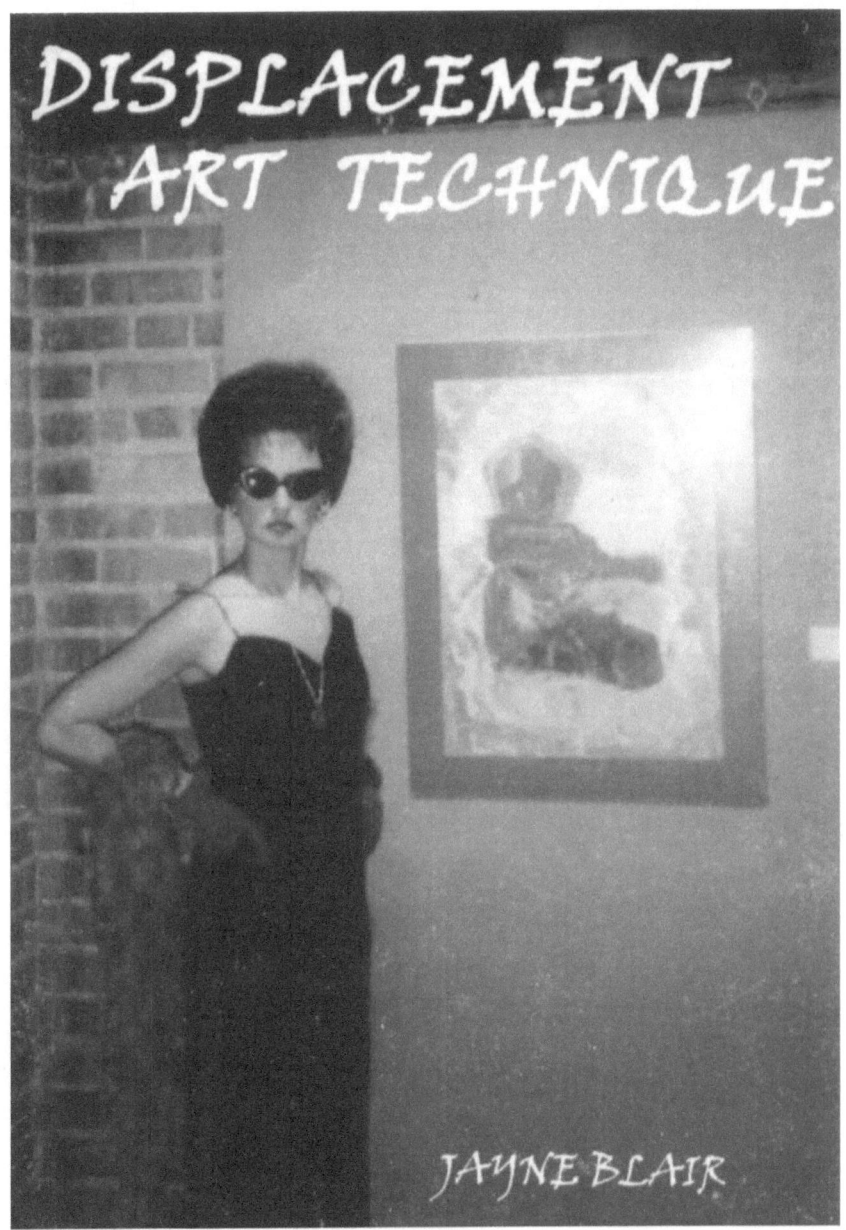

INTRODUCTION

MODERN ART has arrived! Fortunately for the urbane art lover, those of us that hold our breath the eve before an 'opening'; those of us that wait in lines like long cords around THE MUSEUM OF MODERN ART on 53rd Street in NYC to get a ticket or pay only a nickel on Thursday night after 5:00 to 'get in'; and those of us, that will travel farther to get to those old architectural feats, like the LOUVRE, to see the MONA LISA, more than once can be proud. The modern art movement has arrived, and never again will the critics and the cretins, in good judgement be able to cry, 'modern art is silly,' even though as well it is rumored that the master PICASSO himself never painted an abstract painting. And with the stamina, and vision of the lonely artist quest like, JACKSONPOLLOCK, PETITMODERIAN, WILHELMDEKOONING, FRANKSTELLA, MORRISLOUIS, ROBERTTRAUCHSENBERG, ELLSWORTHKELLY, PAULKEE, JOANMIRO, JIMEDINE, JULIANSCHNABEL, and the others, MODERN ART SURVIVED, and will rightfully and permanently hung in history, and in the galleries those rooms and places, where one steps in and is stunned for a moment at something truly spectacular, and reduced to a quiet glance at THE BEAUTIFUL!

THE METHOD

Over the years after my 'art opening' in SOHO, at the ARIEL Gallery, now AGORA Gallery, on Broadway, just up from CITY HALL, in NYC where for a 'moment' I took the art world by storm in first exhibiting 'the plates' of my DISPLACEMENT ART Technique, I have ultimately refined THE TECHNIQUE, making it simple and easy for art workers to use. This way no matter what your background is as a visual art worker, with either an extensive knowledge and understanding of the goals and tools of the art workers studio, or rather a limited one, say a beginner, a novice, or a part-time worker, YOU can use my DISPLACEMENT ART TECHNIQUE, once, or every summer or season to further your development as a VISUAL ARTIST. With my modeling for over 2000 hours in the 'avant garde' and trendy art studios of NYC where I lived for 10 years, I acquired an EXTENSIVE understanding of art workers. From the various array of tools select your choice. You could use PENCILS, CRAYONS, CHALK, CONTE INKS, WATERCOLORS, ACRYLICS, OR OILS. Next decide on the kind of paper or canvas or board you prefer for your work. Then start early in the day and paint or draw the various plates 1-20 with certain shapes and lines WITH the color combinations of your own design. All sizes are acceptable, including 3" x 5", 12" x 9", and so on. Work it up in a couple of sessions and after it has dried enhance using your own judgement and 'taste'. SO SIMPLE AND NEAT!

PLATE 1

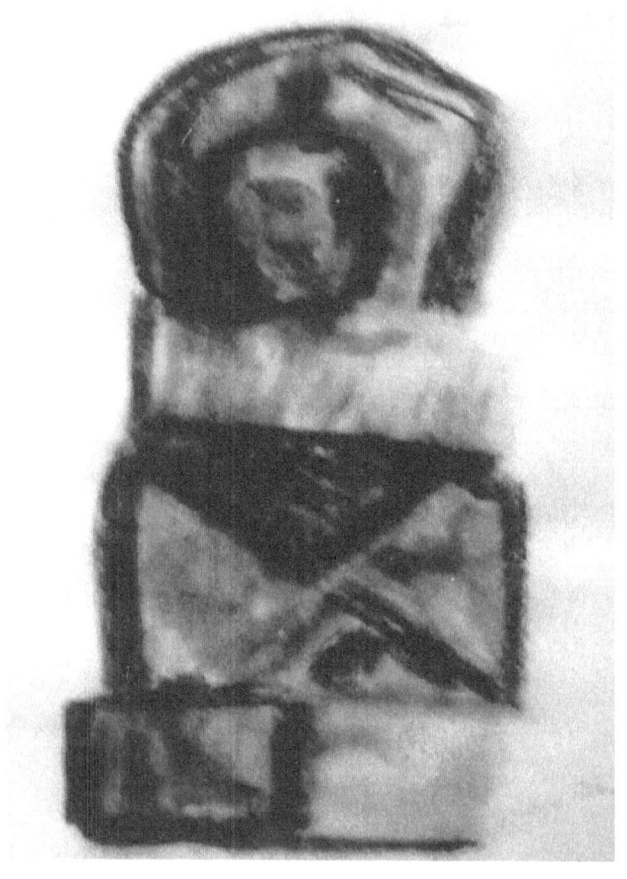

PLATE 5

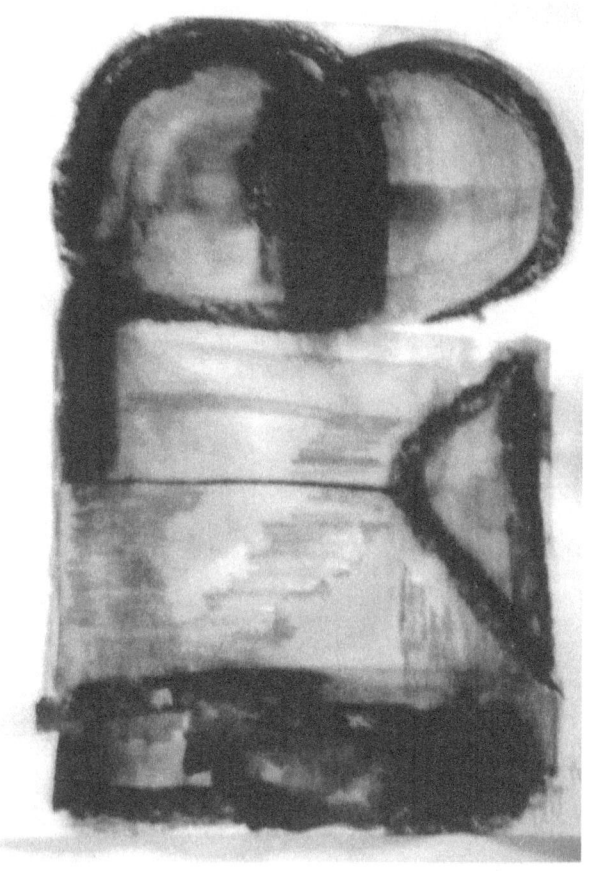

MISS JAYNE BLAIR is collected in the NEW ENGLAND CENTER F.C.A. Brooklyn CT. and hopes to have a permanent gallery with her visual art work exhibited in Ogden, Utah, USA, her hometown.

ARTIST STATEMENT TO THE PAINTED LADY CHRISTMAS TREE SHOW

USE THE SAME FONT AS OF THIS FILE SHOULD BE ON ONE PAGE (CAN REDUCE FONT SIZE)

SINCE THE YEAR 336, BY THE JULIAN CALENDAR FOLKS AROUND THE WORLD HAVE CELEBRATED THE BIRTH OF JESUS CHRIST ON CHRISTMAS DAY DECEMBER 25TH. AS PART OF YOUR HOLIDAY SEASON THIS YEAR MY ART SHOW CAN ADD A FINE VISUAL ART EVENT, FOR ALL AGES TO YOUR SCHEDULE.-- FEAST OF NATIVITY--THE PAINTED LADY CHRISTMAS TREE SHOW CAN EASILY REMIND YOU OF EVENTS ASSOCIATED WITH THE SEASON THAT THE CHRISTIAN COMMUNITY EMBRACES: SANCTUARIES FILLED WITH CAROLS AND VERSE, GREETING CARDS OF GOOD WILL AND THE DECORATED NOBLE CHRISTMAS TREES. HAPPY HOLIDAY SEASON TO YOU.

- JAYNE BLAIR
Jefferson Avenue Ogden UT
E A C Carriage House Gallery
November 4, 2016

JAYNE L BLAIR exhibited over 50 times in Weber County which included hosting 10 oneperson shows and numerous group competitive events like the Utah State Fair in S.L.C., ECCLES (ECAC) entries and the fine art division at the Weber County Fair. Also after opening in SOHO N.Y. City in 1991, she showed in Nevada, California and Canada, collecting 20 ribbons or so, selling her art for cash, developing an ART TECHNIQUE AND PAINTING over 150 plus oil paintings, as local color in OGDEN, her hometown!!!

5 CENTURIES OF CLASSICAL HARP MUSIC

A. Cabezon
1500-1600 Spain

Easily, I visualize with this composition the era of the royalty of Isabella and Ferdinade of Spain during the famous exploration of Christopher Columbus.

J. Pacabel
1600-1700 Germany

Imagine in Europe. the noble proud ships with enormous sails, leaving the dark old port of the coasts and powerfully cutting through the high waves and waters of the oceans endless blue ownership!! Yes like the Mayflower.

Robert Charles Nicolas Boscha
1700-1800 France

This short peice from his STUDIES (recommended to me by D. Nacantor Zabaleta Zala whom I met at Lincoln Center during his recital in 1986) gives me a picture of the era of Geroge Washington

and Thomas Jefferson, when a new sense of leadership, diplomacy and lifestyle had been born in the United States, as THE NEW WORLD. The dancers may have been ready to dance to this music, the MINUET, realizing a future unbounded by the past: NEW, YOUNG AND FREE!!

E. PIZZOLI
1800-1900 Italy

Breathtaking in his skill, Pizzolli's compositions, 4 all together not only suits the harp perfectly and provides the listener with a powerful exhibition of complete mastery of the harp by the performer, the melodies are eternal in strength and nature. The overall rendition leads me to sense the thrust forward seen in the WEST as the creation of the UNION PACIFIC RAILROAD moved it's way to Utah and the Coast with the rails to Promotory Point in Utah!! Near the birthplace where my great grandfather was born in Plain City, around 1873.

Jayne LYN BLAIR
1900-2000 United States

As a witness to my era, my composition (only 7 pages in length) and debuted, and how, in the spotlight at The Marriott Marquis Hotel at Times Square at the 50th Anniversary of The American Harp Society, (I attened the 3rd conference around 1966 in Los Angeles,) carries the audience thru the TIME and SPACE of the unprecedented years of discovery and experimentation, eventually to the Post Digital AGE. complete with the unheard buzz of comradaire, competition, decorated with Medals, Ribbons, Trophies, Overnight Sensations you might say- Millionaires and The Prizewinners!!!

Image caption: Grant Avenue
Farmers Market Saturday
Harp Performance Spotlight

Jayne Lyn Blair
Files Digital Camera
September 14, 2019

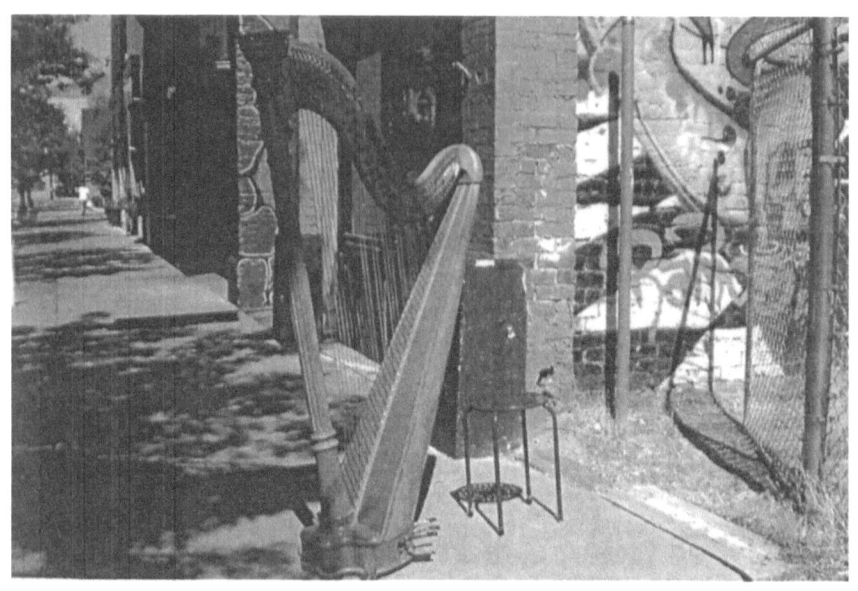

Image caption:
Noon GIG Grant Avenue
September 2019, Summer Market

Miss Blair also moonlights as a classical harpist and sells her FOUR books, softcover published by XLIBRIS worldwide: Perfume, Viva Las Vegas, Hollywood Extra, Extra and JUSTICE. (available at Eborn Books Newgate Mall Ogden.)

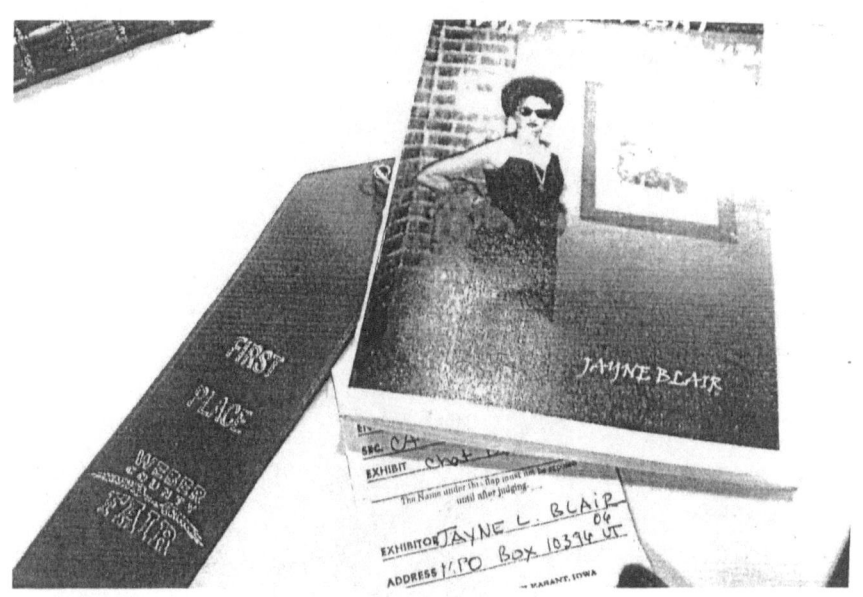

Image caption:
Weber County Fair Craft Division First Place Ribbon Art Chapbook

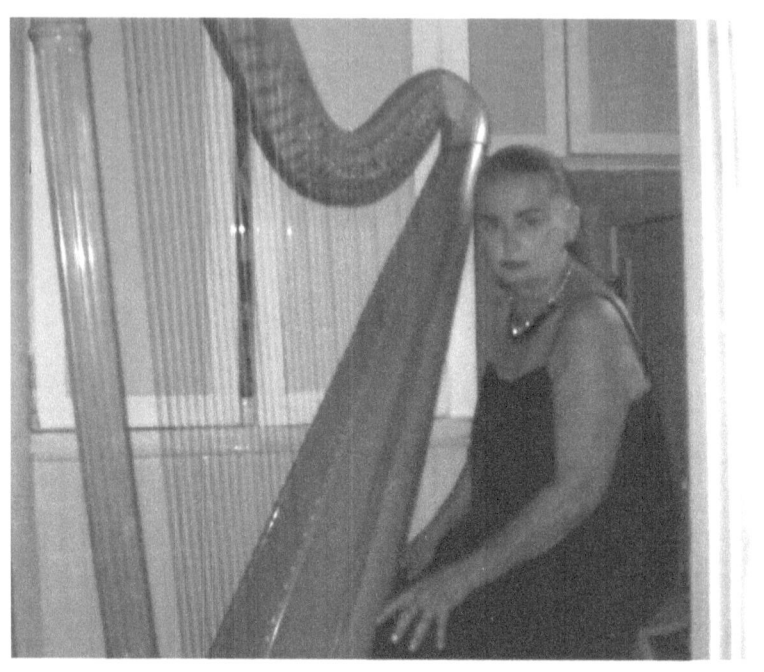

IMAGE CAPTION:
Jayne Lyn Blair files
September 14, 2019 –
Farmers Market Saturday
Grant Avenue noon – 2 hour gig

ACKNOWLEDGEMENTS

E- BORN BOOKS NEWGATE MALL OGDEN

J WILLARD MARRIOTT LIBRARY Special Collections

University of Utah Salt Lake City, Utah

International Society of Poets

Academy of American Poets

Typists: REVAE C Empire Press
 Cheryl All Star COPY
 Debra Muller Eccles Community art Center

City Weekly Newspaper Salt Lake City
Rough Craft Weber County Library

Many Thanks to all my readers!

www.ingramcontent.com/pod-product-compliance
Lightning Source LLC
Chambersburg PA
CBHW021437210526
45463CB00002B/546